IN THE DUST OF
SHADOWS

ISABELLA POULOS

 www.trafford.com

North America & international
toll-free: 1 888 232 4444 (USA & Canada)
fax: 812 355 4082

jan 2013

I

*B*efore time and after the stars had risen,
Born from the sun they descended.
They descended upon the earth
And below the moon they danced.
Amongst icy flowers
And dewy grass,
They held hands and stood below the planets.
United and young, they watched
As the moon and stars
Melted into the sun and warmth.
They danced until time began
And the sun dropped down to kiss the earth
And took them back in its golden arms.
Earth was left with its hard, dark ground
And its icy flowers
And dewy grass,
And the silver moon
Forever glowing.

january 2013

II

A pale mind sees so little,
Sees only two inches in front of the nose,
Where so little occurs.
A pale mind lives for the brightness
Of which it cannot achieve
And curses the gray.
A pale mind dips itself in ink
To sit with its stained mind
And sink into the abyss.

III

Silent in the day,
Noisy in the night,
The clocks remain ticking like a heart.
Swinging pendulums
And cuckoos from wooden birds
Count the seconds of infinite time.
The hands move like the closing of eyelids
As the clocks chime midnight.
Deep as hate yet clear as truthful eyes,
In unison they salute the Master of the Universe,
The Lord of Time.
Together they scream and yell
In the privacy of the blackest of clouds
And the darkest of times,
But whisper and tease in the clarity of light.
The clocks mark meaningless moments
In never-ending time,
Minuscule memories
Placed within the obsidian trident
Of she who yields not
To the passing of seconds.

IV

Sharp and hard
Yet fluid and soft,
It flows and allows,
Permits and angers those who embrace it
And those who don't.
Complex like a child's mind,
It binds and breaks,
Clutters and clears.
The most
And least
Useful group of inventions
Ratifying simplicity and replacing it
With misunderstandings
And misconceptions.
Like thunder in a box,
Behind glass it booms and bellows.
It tangles and unties like the hands of a baby.
Streaming on forever like the tears of a toddler,
It never rests,
Working tirelessly to obey.
Following no footsteps and leaving no trail,
Its existence is invisible,
A tangible form,
Insubstantial.
Erasing minds and tying tongues,
It storms on like soldiers in the sun.

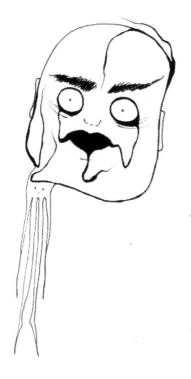

january 2013

V

*N*ever-ending and cold,
It feels its way through the universe
With a frozen soul and pale, thick eyes.
It searches for the infinite end,
Drifting through the air, unseen.
Silent and careful,
It melts with its iciness over all beginnings
To keep them forever moving.
It fears the end
Yet seeks out its enemy with gray,
Wrinkled hands.
Its icy soul
Shivers through
Its invisible existence.
Smooth,
Infinity orbits minds
And coats thoughts with powdery snow,
Defending them
From the burning palms of mortality.

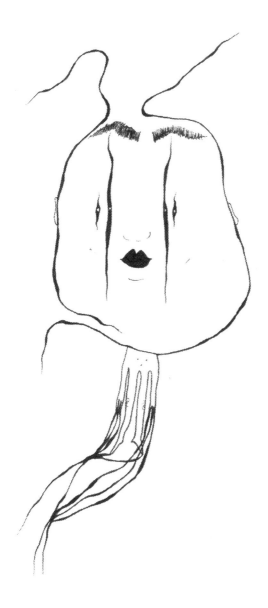

VI

Fantastically bright and glittering,
The magic covers everything with gold.
It flutters and hums,
Tracing circles around the sun,
Putting the glow into stars
And the life into Earth.
It dances on grass
And hangs from singing trees,
Casting an invisible shadow
Onto the ground below.
Delicious and enchanting,
The magic entrances the world
With trickery and warmth,
Stemming from only the deepest of authenticity.
It shines and illuminates,
Brightening all things dark and cruel,
Replacing them with wings.
Golden crowns remain
Atop minds of glass,
Dusted by shimmering disbelief.

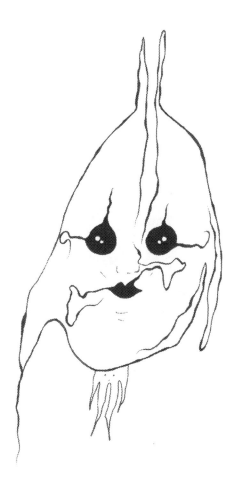

jan 2013

VII

Shiny when new,
New even when old,
Acting as constant companions,
Watchmen and guardians.
Disfigured to make forms,
Scuffled and scratched with age,
They sit poised on shelves and tables,
A reminder of what once was real
And authentic.
Replaced by plastic cousins,
The tin boxes remain veterans of a different time,
Those left,
A dying breed.
Standing their ground,
They melt from their unnatural form
Into beautiful liquid
And seep back into an older time,
Untouchable.

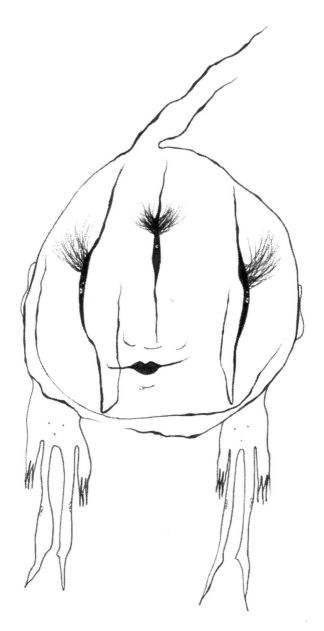

VIII

Free,
Yet contained.
Something composed from hard,
Frigid metal,
Cut and twisted into the most absurd object.
Sly.
Strong.
Oddly useful,
There to resuscitate an empty soul
Or broken heart.
Shaped as a spiraling circle,
A symbol of resilience
And endlessness.

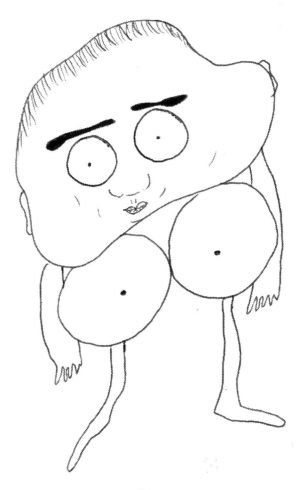

wow

IX

Charred and dark,
Painful and filled with sting,
The degrees of a burn seep through eyes.
Sudden and slow in healing,
They dig
With nails sharp as anger
And tear through layers
Of comfort
And contentment.
Uncomfortable and everlasting,
A deep sensation.
The initial heat becomes intensified
By the feeling of extreme cold,
One melting their way through despair.
Like coal,
It paints the world black
Dusty and dry,
It sets fire to anything it can grasp.
Burns muddle with their sting
And melt with their heat,
As they bind with precision
And control
Through the vastness of their inferno.

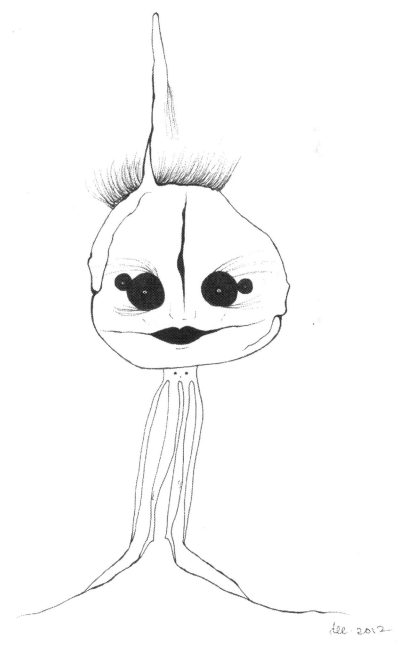

X

Small round orbs,
Opening pathways and leading
To the unknown.
Meant to be opened.
Molded to fit in the palm,
They compel open eyes
And place nostalgia
In those that are closed.
Behind doors these things wait,
Assessed and welcomed
By silvery knobs and golden handles.
These keepers of dreams hold out nightmares
And grasp onto ambition and luminance.
Knobs contort negativity
Into the purest of halos,
Which float atop the passageways
Of imagination
And all things mysterious.

January 2013

XI

*E*choes pierce with their wildness.
Hollow and shallow,
Pulling in listeners
With shadowy arms
And boney fingers.
Grasped by scaly knuckles,
One can only stand with eyes closed
And hear the music of an echo.
Encompassing all with soft notes,
It collects feeling and emotion,
Preserving them in its bronze jar
From which it pulls its song.
Leaving sleepy shells,
The echoes defuse all dispositions.

XII

Royal and soft like rabbit fur,
Warm and elegant
Is divinity.
Wild and silky,
Creamy and sparking,
It flows and billows
Around the moon
And across the milky stars
And crispy planets.
Clean and glowing,
It shapes all things fantastic
With the most beautiful hands.
Calm and regal,
The elegance loves all it meets
And trails across the world
And falls deep into the core of the earth,
Casting golden embers of beauty.
Full of mystery,
It floats through lives
Like a goddess wrapped
In a gown made from the dust of diamonds.

XIII

Red like blood
It flies with song,
Constant and determined.
Sound of strength
Flows through its break
Made of jade
And black diamonds.
Quick as light,
It flutters through the sky,
Below the clouds,
The atmosphere enveloping crimson feathers
In dry air,
Stinging eyes,
Dark as the sound of thunder.

Jan 2013

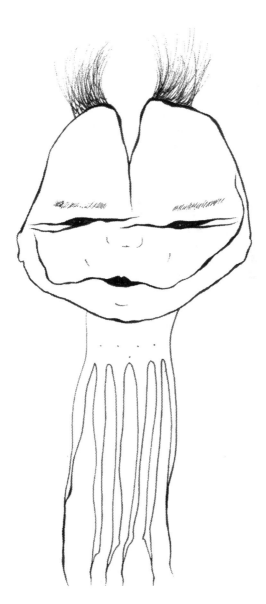

XIV

*S*carred and ripped with experience,
It carries on,
Always watching
With open eyes
And a closed mind.
Self-centered
And cruel,
Barreling through obstacles
And sticking its empty heart
Into the mind of its enemy.
As a soulless shadow,
It thunders and screams in the night
And grins in the day.
Uncontrollable and destructive,
Meant for good
But taken advantage of and manipulated.
It fights.
Tough.
Admiral yet dark hearted,
It astounds foes,
Dripping and gruesome.
Destroying,
It protects itself with chaos,
Striking and tearing
With its furious talons.

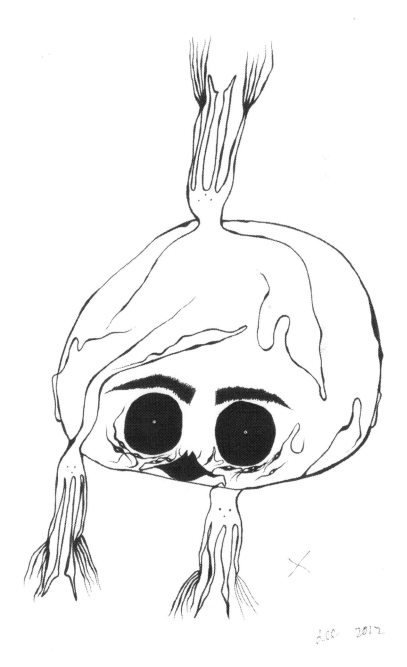

XV

Not as clear as one would imagine,
More muddy than reasonable.
Does it conform
Or seep though the corners
Of the surface of glass?
Like smoke,
It finds its way
Through dreams and nightmares alike,
Casting everything into the gray area,
Neither black nor white.
Like misty sea glass,
It litters the beach of mortality
With half fulfilled ambitions.
Reality fades wonder into compliance
But can also create dreams greater
Than those seen in sleep.
Dirt in water,
It muddles,
Extracting excess
And replacing it
With dazzling truth.

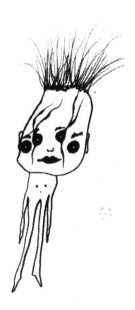

XVI

A soft glow,
The color of saltwater and tangerines.
Warm and plush,
It surrounds and listens,
Whittling away unpleasantness.
Wise and honest,
This serenity wraps each person in strong,
Patient arms
And words formed
From silence.
Completely and utterly kind,
It always waits in the same places,
Ready to dismantle.
Filling up chests and hands,
It spreads like spilt honey
Throughout one's being,
Leaving behind wholesome contentment.
Never rude nor unkind,
This serenity is breathed in,
Irresistible vapor
Enchanting each being
With its sensation.

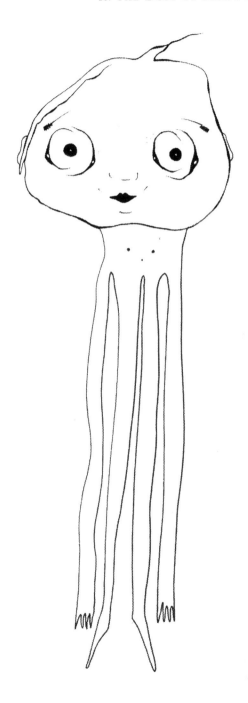

XVII

An idea so desirable
As it is unreal.
The concept of perfection
Only a myth,
A representation never having existed.
Debatably the most individual idea in the world,
Never perceived by two beings as the same thing.
Virtually indescribable
Is perfection.
Natural and manufactured,
It is as beautiful as it is disgusting.
A concept never attained
Or held in hands.
It smolders,
Waiting.

XVIII

Light breaking through
The eyes of a sleeper.
Sudden and deft,
It catches such sleep
And eases in its bleeding claws.
With fear and uncertainty,
It plagues.
An incurable disease.
The only antidote
Rests in the hands of peacefulness,
The moment the dreamer closes their eyes
Once more.
It breaks the binds between the two worlds,
Tearing carefully sewn stitches
From the wound of humanity.
With a sneer,
It pulls one from safety
And implants confusion in its place.
With the sound of cruel laughter,
It flocks through starless nights,
Searching out sleeping, dormant prey.

XIX

A place of perfect symmetry.
Both separating and joining two together.
Carefully placed on a measured line,
The middle represents the separation,
The division,
The thing that makes one into two.
Furrowed deep into the earth,
It lies in the ground,
A burning equator of disharmony.
The sky,
A complete whole,
Untouched by judgment,
Immortally one and undivided.

dll 2012

XX

Glistening with dew
As the forest chimes and purrs.
Green as emeralds.
Delicate flowers and birds
The color of sunrise
Sway through the air
And sing with their fellow creatures.
Rain falls like gems
And shatters.
Young,
Yet ancient as the wind,
The forest ages in reverse,
Becoming more childlike
With each new birth
Of each new child
Of the roots.
Kind and regal,
The trees stand as guardians against time,
Defending their children from the destruction of morality.

XXI

So soft,
Like a hat for our toes,
Woven and fuzzy are socks.
They lay strewn across rooms and houses,
Pairs losing the other,
Mismatched with cousins.
A fraction of self-expression
Flowing not from one's words,
But from inside shoes.

XXII

*E*ach one cut to a different shape,
Every key unique.
Tiny and easier to lose than to find,
Each one is the holder
Of a different mystery,
A different secret,
Special and terrible enough
To need to be hidden.
Each of these things becomes untangled
By the metal creature with jagged teeth.
Unlocking the secrets of both worlds
And every universe,
The keys move on,
Turning in hands,
Opening secrets
With their pointed smiles.

XXIII

Clear and pure,
They chime silently.
Shattering light into a million flecks of color,
Chilling the depths of the ocean
With its hollow voice.
Holding seashells and memories,
Together, they sit upon days forgotten in time,
Waiting to be reopened.
Smooth as eyes,
The glass purifies
And emits
Nothing but radiance.

Jan 2013

XXIV

Seeing both truth and lies
In the mirror,
A vortex sitting among the stars,
A dark enigma,
Waiting.
A portrayal of images
Reflected a million times,
A thousand different versions of one seen.
To see too much
Would be to look within this mirror,
To see behind eyes
And below brains.
Compelled to find more
Of what lies under skin
And within bone,
But afraid,
Afraid of what might be uncovered
And reflected large enough
For hungry eyes to see.
Like tears to the touch,
Secrets lie between layers of weeping glass,
Unfolding themselves with gasps.

XXV

With royal bodies draped in blood,
The castle houses legends and mysteries.
Private passageways mutter,
Surrounded by stone walls and velvet rugs.
Regal, peaceful, it rests
But never closes its eyes,
Always prepared to protect
The royal bodies within.
Its towers pierce the bellies of clouds.
Crafted from the most ridged stones,
By bloody, torn hands.
A hidden mind,
A soul trapped deep within rock,
Resting quietly below such ruined feet.

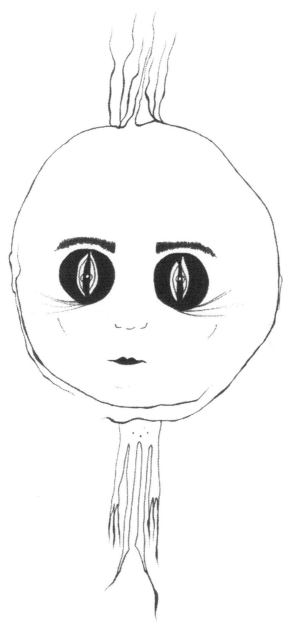

jan 2013

XXVI

*L*istening
With four ears and no eyes.
Playful and sweet,
The buttons frolic in fluids of yarn and string.
Even when tied down
To jackets and pants,
They remain amicable
Despite restraint.
They giggle when the lights are turned off,
Smile without mouths,
And see
Through only what they hear around them.
Round and soft
Like small people,
They breathe
Without noses
And smile
Without lips.
Strewn across our closets,
Secret and silent,
Companions on every shirt,
Always listening.

XXVII

Smooth,
Like grease it crawls across the ground.
The earth absorbs the oil in thick gulps,
Chewing on the unnaturalness.
It slips with a sly smile
Filled with yellow teeth,
And releases its tar-like saliva.
Smelling of lead paint,
The slickness coats,
And eventually drowns,
With its slime.
Covering grass and daffodils,
It leaves everything dark blue and sticky,
So slick.

XXVIII

*T*angy with the sweetest aftertaste,
Balanced,
Lingering.
It sleeps on the backs of tongues
And the surfaces of teeth.
Small enough to fit in the palm
Of the hand
Of an infant
Is the flavor tart.
Sour and delectable,
It tiptoes across palates
And tickles molars with its flavor.
Like a translucent lemon,
It waits for the moment
In which it is devoured
And turned into sweetness.

XXIX

\mathcal{A} contraption meant only to keep things in,
Made from metal,
Cold and hard,
It traps in unwilling, unfaithful prisoners.
Crossed bones,
The cage restricts,
The stomach of a monster.
Grasping onto happiness,
Cruelty,
And memories made from coal,
These prisoners are forced by this cage
To see what brings them all together,
That each of these things is a weakness.
They are the weaknesses of each person who holds them,
Attaches to them and for which,
They themselves are imprisoned.
Their words reach between these bars of bone
And grasp the air with nail-less hands,
Searching the silence for rest.

del. 2012

XXX

*G*limmering and blissful,
Composed of no real color at all,
Invisible.
They lie within the air
And breathe in our breath.
Calm and made of all good,
They illuminate.
Spreading to unexplored hearts,
Like silvery water
Flowing with our blood
And resting in our skin.
Buried deep within,
Never seen,
But felt.

dee 2012

XXXI

*F*orged by blistered hands.
So pure and golden,
Encrusted with rusted tears.
Rubies and sapphires
Placed on the spires of this crown,
Beautiful, rich skulls.
Watch them now.
Mischievous and quiet,
Purring.
The gold,
Melting unnoticeably below her skull,
Coats her mind in its beauty.
Thoughts and ideas touched by gems,
It intoxicates with molten syrup,
Tapped from its fingertips.

XXXII

*D*ark and beautiful,
Completely terrible
And haunting.
With wings forged from terror,
They feed on fear
And thrive within weakness.
Demons follow,
Grasping with black fingernails and ripped skin.
They paint the moon red
With the sores of their brains.
Enticing with thin, blue teeth
And black eyes,
They invite those who are willing
To wear their cloak of the night.
Demons lie
And cripple happiness
Into orbs of dust,
Which then float up into the sky
As black holes.
They prey on whoever can be reached,
Speaking without tongues
And tying up their worshippers
With the feathers of their demon wings.

LOL Jan 2013

XXXIII

They live together in the soft earth
Covered in roses
And silt
And sunlight.
Laughing below the eclipse,
Tasting like sugar,
They melt
And roll their way down
To lie on their child.
Glowing from the inside out,
A golden heart sits within,
Illuminating the sky.

XXXIV

Piercing and deep,
It slithers and seeps through one's soul and body,
Engulfing and surrounding a golden aura
With the blackest of smoke.
The grayest of eyes watch the disintegration
Of one emotion into another,
Judging and harsh,
Touched by jealousy and anger.
Sifted and strained,
It hides and breeds within,
Consuming the theory of balance.
Uncomfortable and mesmerizing,
It conforms and solidifies,
Encasing one in a shimmering layer of the unknown.
It leaves behind hollow eyes
And a mind
Tainted by secrets.

XXXV

\mathcal{A} visual representation of time,
Carrying the world in its penetrable layer.
Thin yet tough,
Taught.
The knives of time poke holes
And cut lines across its forehead.
Green and dark,
Soft when new,
Slowly becoming sunburnt and torn,
Sagging with the passing of each second.
Like a map,
Lines across the skin,
Carved deep into
This
Skin
By moonlit swords.
Broken,
Iridescent liquid flows from the gap.
Drowning in the fog of one's mind,
It suffers.

January 2013

XXXVI

It drowns
And laughs
As it twists.
It stings with every breath it takes.
Deep and quiet,
It spins through rooms
And atop fire it dances.
The color of nothing,
It is chalky to the touch
And appears to be beautiful,
But leaves black streaks
When caught by little hands.
It stings eyes and fills mouths,
Choking slowly.

XXXVII

Something to be careful with,
Something to cherish,
Something to hold onto,
But not too tightly.
Thin and ready to break,
It barely moves,
And when it does,
It stands up from its chair
Of soft gold
And walks gingerly,
Never moving too fast.
Guarded and tiny as can be,
Its heart beats with a flutter of wings.
Clear and shiny,
One may see this heart,
The color of laughter.
To be delicate
Is to be careful and mindful,
But not too still.

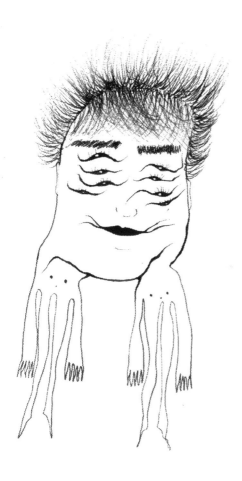

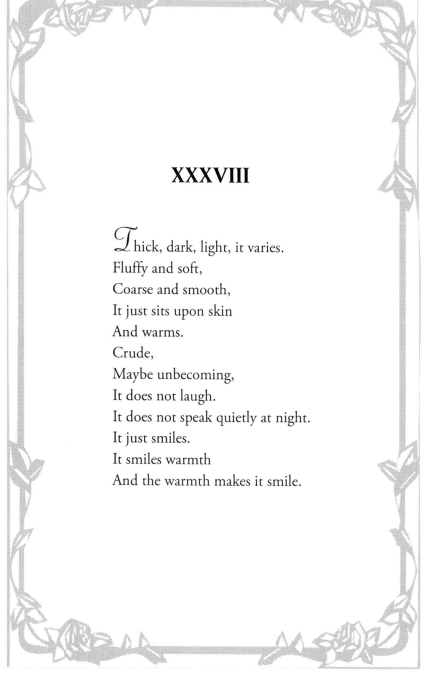

XXXVIII

Thick, dark, light, it varies.
Fluffy and soft,
Coarse and smooth,
It just sits upon skin
And warms.
Crude,
Maybe unbecoming,
It does not laugh.
It does not speak quietly at night.
It just smiles.
It smiles warmth
And the warmth makes it smile.

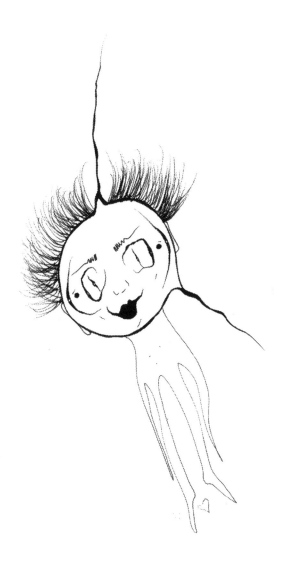

XXXIX

*A*s crinkled paper,
It layers itself upon skin.
Around mouths and eyes,
Sleeping, slowly exhaling years.
From frowns,
They pout with arms crossed.
Between brows,
Creating the furrow.
The lines lead to nowhere,
Going in wide circles,
Covering the face with imperfect spirals.

XL

Plump enough to be completely solid,
Juicy and never hollow,
It finds too many things funny.
Rolling and playing in tall grass,
It loves to be lost.
Forever six years old,
It does not age after that.
It stays careless and kind
For the rest of its six-year-old life.
Tasting like strawberries,
It carries its essence
But can't be alone,
Forever six years old.

January 2013

XLI

Always surrounded,
It surrounds
What surrounds it.
It doesn't spread,
But waits.
It waits for unlucky adventurers
To dive too deep.
Here is where things begin to char.
The deep awaits.
Old but not tired,
It closes its huge eyes
To remain wise,
And spreads its arms.
When an adventurer is near,
The deep knows
And it wraps them in its flesh
And whispers, "Welcome."
It welcomes them to the deep,
Smiles with magenta gums,
And releases back into the shallows.

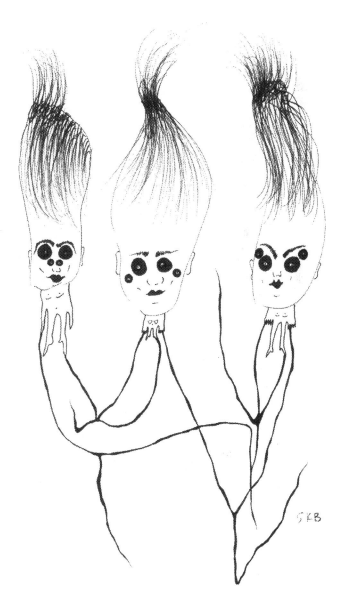

XLII

Leaving holes in the ground
And dust in the air,
They look to one another
With low eyes
And snickers waiting
On their tongues.
Screaming,
Pointed ears follow pointed nails
And distorted faces.
When falling back from their flight,
They crash into the core
And fire crusted embers.
Cackling once more,
They run through clouds at nightfall
And fling themselves sacrificially
Upon the moon.

Isabella Poulos
Jan 2013

XLIII

Creatures in need
Of safety
Or quiet
Find any nook and hide.
They seek cover by nature.
Within the world, they hide
And look around
With anxious eyes,
Scared and nervous,
Hoping never to be found.
From the world,
Unsure of what it means
To be one of its creatures.

XLIV

Stacked in piles,
Built up from the ground
And built down from the sky.
These structures stand tall.
Rugged and smooth,
Carved from the same ground,
Here for the shadow,
Those from nature
And those for man.

dec 2012

XLV

Twisting through air and water
To only be stopped by the two-dimensional.
Clustered within noses
Of which it may not be recognized,
It falls
And pulsates
And is derived from no origin.
It incises the ground
And shatters the stones and vines
That keeps all from floating away.

XLVI

Before the anger,
Before the fire,
Before the blood and dirt.
Before the rain and mud,
Before the tears and darkness.
Before the open eye,
Before,
There was night.
Before the color,
There was blackness
And before the breath,
There was sweat.
Before the water,
Before the warmth,
Before the strength and fight.
Before it was over.

jan 2013

XLVII

There are many kinds of wings.
Some of ruby,
Some of jade,
Depending on the lies
Or truths
Within the feathers of the host.
Beautiful with soft feathers,
A symbol of dignity
And purity.

XLVIII

Conceived from greed and selfishness,
It eats as its skin tears from ear to jaw.
With dark eyeballs,
The power watches.
To the touch,
It is cooler than cold metal
And softer than fur.
Leaving black marks on trees
And scars in the grass,
It sweats bronze and cries emeralds.
A body, but no face,
With empty thoughts,
Power tastes its lips.

dee 2012

XLIX

*I*nnocent
But not necessarily young.
Old too,
It can be rough.
Just as long as it always tastes
Like burnt caramel
And has blue eyes
The color of the ocean.
Sweet and loveable,
No matter how soft,
How wrinkled.

L

*S*mall and brown
Left by the sun,
And some from the moon.
These are the ones that are brightest.
Rare and even smaller than those of onyx,
Each a tiny version of its father.
Growing with the eclipse
And shrinking with the sunrise,
Crystalizing in a pool of silken mist,
To come and rest above veins.

dee 2012

LI

Small and soft
Like a tiny baby
Hanging onto one's ear,
It just sleeps.
Tired like a child,
Barely spending time with its little eyes open.
Some small
And other thick,
All equally majestic in their own ways.

MR. GOLDFISH.

LII

Speaking through the wind,
Creatures whistle and whisper.
Louder than waves
And softer than the brush of lashes.
Soft and light,
With each movement
They burn images
Onto wind and pages,
Colorful as they were in the mind.
Giving as much feeling when spoken
As when written,
Lips.

dec'12

LIII

Squinting eyes
And knitting brows.
Placing a roof above the world,
A lid screwed on tight,
Keeping in and out.
No sky,
No clouds,
No sun,
No stars,
Only the gray.
Thick,
Colors work twice as hard
To be seen by the squinting eyes
And covered shoulders
As it brings in fistfuls of gloom.

dee 2012

LIV

One color,
One time,
Many lives becoming one.
Dripping into one another,
The red sun blending
Into the white moon.
Skin becoming one with bone,
One organism
Becoming another as it grows.
Stitched together by yellow nails,
Taped upon one another by sticky hands.

LV

*M*ade a certain way
All to please and to be particular.
Uptight in this particularity,
Too bright
And too dim,
Too soft and too smooth.
When it is done,
It feels so perfect
And wholesome,
So together and so new.

LVI

Corners of tables and desks,
Sharp and cold,
Dragging blood.
Perfectly straight and cut
And reassured,
They wait for stray elbows
And wandering knees.

LVII

*J*ust a little off,
Not perfectly placed or lined,
And lines curve off into the sideways distance.
Running in zigzags,
The crooked turns and changes course,
Forbidding itself from following
The straight line already set.
Frustrating and awkward,
One always wants to set the crooked straight
And make it flow in the precise direction,
But soon realizes that it will always
Be zigzagging,
Pleased with such a curving journey.

LVIII

A universal language,
Understood by all who has ever seen
Sharp shapes.
Perfect, they live in the shadows of pencils.
Like letters they are read.
Forming different kinds of sentences
And different kinds of phrases.
Formed by lines, they intersect,
Never ending letters,
Gracing with complexity.

LIX

Clinging onto steeples and rooftops,
The air is sniffed by stone noses.
Horned,
Scaly skin,
Their eyes are flesh-toned with black pupils.
Made from rock,
At night they fly,
Protecting the buildings
That are their chapels.
Loyal, always returning before the sunrise,
Brought to life by the pure,
Bright moonlight,
Their howls carry throughout the midnight air,
Turning enemies to stone
As another is incarnated.

LX

*P*eeling and crusty,
Falling off,
Another layer gone.
Living within a person
And lost from the inside outwards.
Losing its beautiful colors as it falls to the ground.
Now dull and lifeless,
One must hope a person has more of these things
Than what was shed.

LXI

First
Many colors are seen
In the corners of one's eye,
Which then fade into dismal gray.
Gray clouds the mind
With its ashy smoke
That falls and stings the brain.
Constant and delusional,
It jumbles thoughts and tangles itself
Around the infectious mess
That pulsates through the brain,
And into the cornea,
And out through the nose,
Spilling like tar.

dec 25 2012

LXII

Short and plump
Like little oranges,
The little men sat on the daisies and roses,
Under the tall olive trees.
Wearing little tweed jackets
And little blue shoes,
The little men left little footprints
In the silky mud,
Among tiny purple beetles
And small pink caterpillars.
They ate juicy green apples and thick yellow pears
While they sat on the daisies and roses
Under the tall olive trees.

LXIII

Some walk on six legs,
Others slither on none.
The ones that walk on six legs
Lie on the ground,
Pawing the earth with padded hooves
While the earth gradually swallows
The ones who slither.
They are the glistening water,
The products of sunlight,
And the kin of dirt.

LXIV

Stones under the skin
Covered by soft flesh.
Bones filled with marrow
Caving beneath shy tissue.
Between tendons they remain,
Connecting to the smaller things
And the larger ones.
To feel this table
And to touch this hand.
They themselves never feel
And never touch,
But understand
And yearn for the pain
Of extracting themselves from soft flesh.

dee 2012

LXV

Cascading over one's eyes,
A rippling blanket of silk,
Slipping over the mind,
Covering all things in the brightest darkness.
To come this close
To death,
To the unattainable,
Is impossible elsewhere.
But here is elsewhere
Where anything is possible
And all things are unreal.
The only time where everything is false,
Yet indistinguishable,
From the place where we live
With our eyes open.

2012

LXVI

*W*rapped around broken bones,
Soaked white by musty water.
Congealed,
Clinging to gums they rest.
They are intertwined with hair,
Dirty hair dripping oil,
From which they attempt an escape.
But from this hair they are derived,
Tangled and sweet,
Waiting for the water.
Ripped from mouths and bones,
They rest inside the trachea,
Rising and falling.

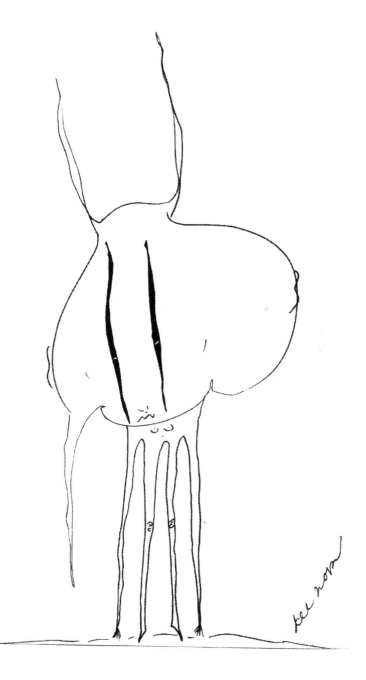

LXVII

With fire it lives,
Only moving with the touch of a flame.
With the heat it is melted and burned away
By the same thing it finds life from.
From its heart this flame lives.
It breathes in the smoke it gives off
And feeds on the wax home it is forever placed within.
By living, it gives as much as it takes,
The precious flame dancing in its melting heart,
Flickering and glowing,
Living
And giving life.

fucking scary.

BABY DEVILA. 2012

LXVIII

\mathcal{T}hin iridescence,
Sending down a furious burst of tears.
Gently, they drift into the hands of the tangible
And die immediately.
The flesh,
The graveyard of such delicacy,
With tombs carved from wood,
Painted with the juice of berries,
As this iridescence floats.
Eventually reaching the graveyard,
The tears of its nonexistence
Rebirth them like a phoenix.
Alive within their graves,
Pounding on the wood,
Scratching at the juice of berries,
Covering themselves in dirt,
They live in death
And cry below roots
As we hear nothing
But the sound of a million
Furious bursts of tears.

dee 2012

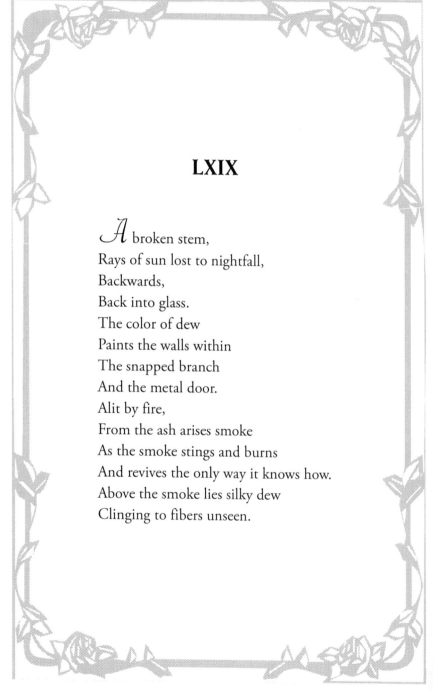

LXIX

A broken stem,
Rays of sun lost to nightfall,
Backwards,
Back into glass.
The color of dew
Paints the walls within
The snapped branch
And the metal door.
Alit by fire,
From the ash arises smoke
As the smoke stings and burns
And revives the only way it knows how.
Above the smoke lies silky dew
Clinging to fibers unseen.

LXX

Beauty found in symmetry.
Eyes blink too fast to see
As unspoken words lie in the depths
Of this median.
Clouded by expectation,
The realness of what lies in front
Goes unseen
And untouched
And uncared for
As all that is seen is what is missed between
The rapid blinks of an eye.

LXXI

So divine with death.
Surrounded by supple dust,
Earth in which it grows from,
All held together by the passing.

LXXII

Unmoving, unable to hear,
Craving the taste of pool water,
Seeing blurs
And feeling the coldness.
The pressure rises and falls until
It is lost,
Only to resume weeks later.
A spider's legs scratch the skin
As it drifts its webs beneath
The silent mouth.

LXXIII

Waiting in the heat,
Pupils explode
As nostrils drip blood
And mouths breathe silence
And hands feel the warmth.
Caught in a net woven from hair,
Repulsed by the surrounding,
Embarrassed by the waiting
And craving the sleep,
The irresistible sleep.

LXXIV

*I*nside this house of marble we live
Where clouds form on this ceiling
And rain falls onto this carpet.
The moon rises above this door
And the sun sets below this welcome mat.
From this house of marble
We observe through tinted windows
And walls made of stone.
This house creaks
With the sighs of one thousand breaths
And two thousand footsteps,
Crushing down
On the golden handle I had made
For this marble home.

Isabella Paulos
Dec 2012

LXXV

The roundness slides,
Smooth and cold,
Out of hands.
Infinite and silky,
It comforts and sweetens the dullness of boredom
And entertains lifelessness.
Absorbent and tangled,
The roundness grows and thrives
Within concrete lives and riskless adventures.
Calm,
It rolls through deceit and leaves a sticky trail
Over what once were lies
And replaces them with honesty.
Adorable and soft,
The roundness enhances memories
With tidy hands that leave little prints
On lifeless existence.

LXXVI

Falling into the beauty
Of the endless waiting
And the countless suns unseen.
Feeling the stares of unrecognizable faces
And the sound of shoes moving towards shoes.
Miles apart and so deep we may fall
Into the beauty.
On a bed of lashes,
Resting heavy heads
And hearts of stone,
Filling bowls with mud.

KITTY